Return items to **any** Swindon Library by closing time on or before the date stamped. Only books and Audio Books can be renewed - phone your library or visit our website,
www.swindon.gov.uk/libraries

Central 07/19.
Library
Tel: **01793 463238**

12.10.19
14/11/19

Copying recordings is illegal. All recorded items are hired entirely at hirer's own risk

THOUGHT

Swindon
IGH COUNCIL

ORION PLAIN AND SIMPLE

handwriting

EVE BINGHAM

SEVEN DIALS

Previously published in the United States in 2007 as *Simply Handwriting Analysis*
By Sterling Publishing Company

This edition first published in Great Britain in 2019 by Seven Dials
an imprint of the Orion Publishing Group Ltd
Carmelite House, 50 Victoria Embankment
London EC4Y 0DZ

An Hachette UK Company

1 3 5 7 9 10 8 6 4 2

Interior design by Kathryn Sky-Peck

A CIP catalogue record for this book is available
from the British Library.

ISBN (Mass market paperback): 978 1 4091 7035 8
ISBN (eBook): 978 1 4091 7036 5

Printed and bound in Great Britain by Clays Ltd, Elcograf S.p.A.

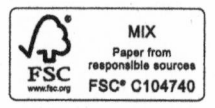

www.orionbooks.co.uk

I dedicate this book to my husband, Dave,
for the culinary delights and the numerous cups of
tea, and to my sister Val, for her much appreciated
grammatical expertise.

CONTENTS

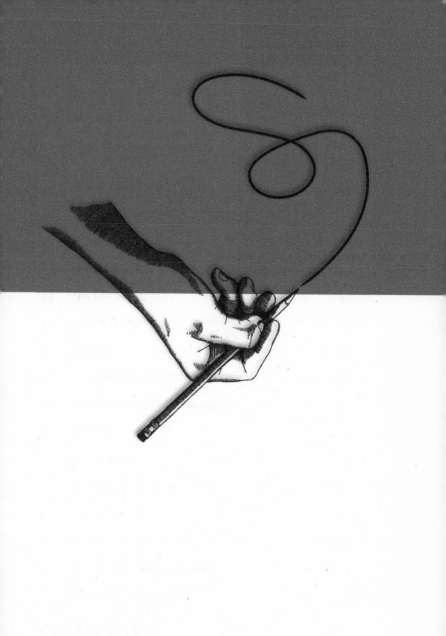

Graphology

When we were very young children, we were encouraged to draw and color pictures, but the first time we held a pencil or crayon in our hands it felt awkward and rather strange. With continued use we became more adept, but it was only when we arrived at nursery or elementary school that we were taught how to draw a picture and then sign our names at the bottom of it, usually in capital letters.

Today, our children are encouraged to develop hand-eye coordination, and most of them are able to read and write their own names by the time they reach elementary school. Writing is taught in elementary schools, with children first being taught to form letters of the alphabet, and later being taught cursive. We all have memories of the triple-lined paper we were given so we could practice staying on the line, and make sure our letter forms reached above or below the center dashed line as instructed.

A child's drawing, signed

As the years go by, a child's unique expression of writing develops. Over time, and with the encouragement of their teachers, a child's writing becomes more practiced. Most children are taught to write in a similar way, but by the time they reach the age of about twelve years, they choose to vary their writing style in accordance with their unique personalities. From that time on, their signatures become expressions of who they are.

The study of handwriting is referred to as graphology. Handwriting can also be regarded as "brain writing." It is an expressive action that reveals the whole personality; each mark on the page contains meanings that a graphologist can interpret. By the time adulthood arrives, all our experiences—the untold twists and turns, ups and downs, highs and lows of life—are reflected in our handwriting. The overall presence of a writing sample on a plain piece of paper can denote a person's unique and individual expression of the inner self. However, while there are many traits we can identify through handwriting analysis, and many ways to identify those traits, keep in mind that it is not possible to identify the gender of an individual from a handwriting sample, or to use graphology to predict the future.

Before you begin to explore this stimulating subject, it would be helpful to collect several handwriting samples from friends and family. Just a few words positioned on a piece of paper, greeting card, or envelope will portray a lot about the writer of those words. Collect as many as possible, and with some practice you will be amazed by what can be revealed.

Different writing characteristics are called "handwriting indicators" or "writing traits." The many script samples in this book include examples of size, slant, pressure, baseline, connection of

letters and words, margins on the page and envelope, the three zones, and the signature.

Nowadays, many companies use graphology as an unbiased tool to determine a job applicant's suitability, making handwriting analysis an effective, profitable, and legal means of screening employees. To many, graphology is on par with fortune telling, but some of the largest corporations take it seriously enough to request that job applicants apply in their own handwriting.

Throughout the ages, humanity's method of communication has been primarily in the form of the written word–letters, notes, postcards, lists, reminders, and maybe even a daily diary. Nowadays, however, we rely heavily on technology—computers, cell phones, and so on—to communicate instantly with one another. This is particularly obvious among the members of the younger generation, who, it seems, rarely put pen to paper.

Our handwriting is the product of mind and body because it is composed of thoughts expressed on paper, with the physical movements controlled by the brain but using the muscles of the arm and hand. These movements are influenced by our feelings— our moods, emotions, and reactions to whatever is going on in our lives at that time. Whether we are depressed or worried, have feelings of optimism, anger, or elation, they all have a bearing on the way we write. Our innermost personality is shown on the page at the time of writing.

Whereas a person's handwriting represents the way he or she feels inside, a person's signature represents the public image that the writer wants to project. A wide variation between a person's writing and his or her signature indicates a big difference

between the private and public selves. When the writing and the signature are identical, then "what you see is what you get."

An ideal writing sample should be written spontaneously, in ink, on unlined paper, and should be signed by the writer. A sentence or two with a signature, or sometimes a signature alone, can be sufficient for the purposes of analysis if there are enough letters within the sample. A considerable amount of handwriting analysis is common sense. For instance, people who dot their i's and cross their t's precisely tend to be more meticulous than those who do not. Stylish people often have very stylish writing, and so on. Much of what you learn in handwriting analysis will not surprise you at all. The more you learn about graphology, the more you will learn about your friends and family.

Size:
An Indication
of Presence

1

The size of the script is the first thing we will look at. There are basically three different sizes of script—large, medium, and small—but I have also included a discussion of very small script. Size of script expresses personal self-esteem, self-confidence, and adaptability to other people. Varying sizes within the same script indicate that the writer can be inconsistent and rather erratic.

The size of handwriting in graphology is important, for it reveals how he or she feels about and interacts with family and friends. The size of the writing is one indication of how much the writer wants to be noticed in much the same way that clothing style and color does. When we look at what people are wearing, we assume that someone wearing bold colors wants to be noticed more than someone who chooses to wear neutral tones.

Usually the first thing we notice about someone's handwriting is the size, especially if it is particularly large or small. Just knowing the sample's size opens up an insight into the writer's personality.

Large Writing

People whose writing is large tend to stand out in a crowd. They like to be noticed and thrive on being the center of attention. These people are ambitious and confident, they tend to have a broad perspective on life, and they can make an impression on

and the new year in

Large handwriting

everyone they meet. They are bold individuals, driven by their egos. In handwriting, large, bold writing typically says, "Notice me!" People with large handwriting may be those in the public eye, such as politicians, television personalities, pop stars, and actors.

Some positive keywords

active

adventurous

good self-esteem

possibly overgenerous

self-confident

self-reliant

Individuals with large handwriting can have great organizational skills and can show courage and a strong character. They do things on a grand scale but they are not good at handling details.

Some negative keywords

arrogant

boastful

conceited

easily distracted

extravagance

insensitive to others

lack of self-discipline

poor observation

possibly accident-prone

vague, nebulous concepts

Medium-Sized Writing

Something else, but

Medim-sized handwriting

Those individuals whose writing is medium-size, or normal, are flexible and adaptable. These practical, realistic, and balanced people can work well on their own or with others; they can be team leaders or team players and have strong organizational skills. A writer of this type might be found in a large company as the office manager, plodding away with repetitive work but still having the ability to monitor the activities in the rest of the office. People with medium-size writing tend to have a sensible approach to life, know how to keep a balance between work and play, are well-liked in their working environment, and have many friends.

Some positive keywords

adaptable

caring

flexible

good judgment

practical

sensible

sociable

trustworthy

Some negative keywords

judgmental

nosy

overfriendly

pedantic tendencies

Small Writing

for your reply. Thankyou.

Small handwriting

People with small handwriting tend to be objective in their out-look. They are usually private individuals who avoid the limelight and keep very much in the background. These are people who use their brains rather than their brawn. People with small hand-writing have a tendency to analyze everything, including their own thoughts and feelings.

Some positive keywords

maturity

prudence

realism

Some negative keywords

feelings of inferiority

inhibition

self-limitation

Very Small Handwriting

a full recovery

Very small handwriting

Tiny writing is associated with very intelligent people who intel-lectualize most things. These modest, humble people can be introverted, but they have good concentration skills. Very small, cramped handwriting can reveal an inferiority complex. People with very small handwriting are introspective and do not seek attention for themselves; they value their privacy more than any-thing else, and being of an introverted nature, they find it hard to interact with groups of people. An individual with very small handwriting is hiding his or her personality behind a facade of caution and reserve; this person is not interested in an active social life and can be discriminating when choosing close friends and associates.

Some positive keywords

accurate

can concentrate

modest

Some negative keywords

limited interests

little creative imagination

pedantic

self-inflicted isolation

submissive

temporary depression

Some doctors have such small handwriting that it is practically illegible. Scientists, researchers, and mathematicians, and also those who are dealing with facts and figures, are normally found to have very small writing.

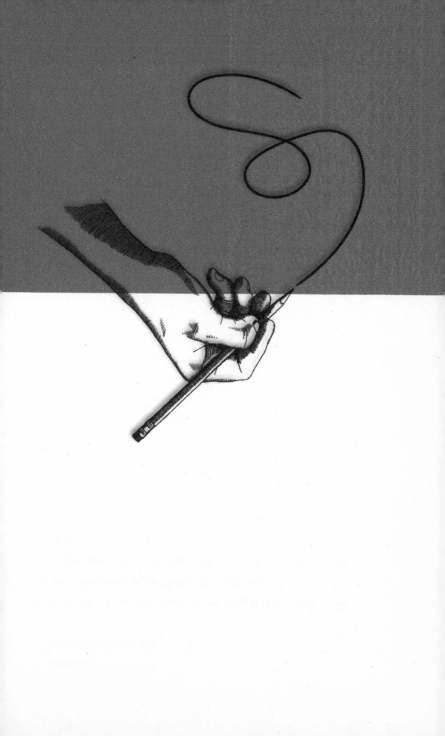

Presence on the Page

2

Margins are like the framework of a picture; in this case, the handwriting is the picture. Margins are not consciously made. These spaces show the influence that time and the experience of life has had on the writer.

Margins

The Left-Hand Margin

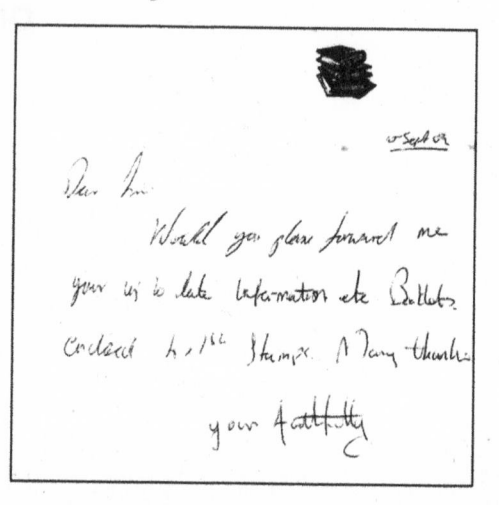

The left-hand margin denotes the writer's past influences and the way he or she uses resources. No left-hand margin suggests that the writer lacks self-confidence and could be clinging to the past. It indicates an insecure individual who still suffers in some way from childhood fears or is badly influenced by his past experiences. People who leave no left-hand margin are afraid of being influenced by others and they can overreact to any kind of criticism or change. A very wide left-hand margin can denote

a writer who is generous and reserved; it can also mean that the writer can be thrifty but also wants to be popular.

Sometimes, if the script has been written quickly, the left-hand margin gets progressively larger, with the writing starting farther to the right with each line. People who write like this are impulsive, and this trait can indicate an excitable writer who rushes ahead when starting something new, for example, an enjoyable project, a new relationship, or a vacation. This trait can also indicate that the writer is losing control over his or her finances. Sometimes, however, the writer will become aware of this tendency and try to rectify this trait by starting the next paragraph back on track.

The Right-Hand Margin

Some irregularity in the right-hand margin is natural; the writer must decide whether, at the end of a line, the next word will

actually fit into the remaining space or whether he or she should divide the word in two using a hyphen. Planning ability, or the absence thereof, is reflected here. Those who have had secretarial or office training will probably control the use of their margins as they would when using a typewriter.

Writers who rush to the edge of the paper and leave no margin at all, can be uninhibited and involved with everything and everybody around them. They probably have no fear of the future, meeting it head-on. The person who leaves a wide right margin possibly fears the future, but this trait can also demonstrate artistic abilities, particularly if the right margin is the same size all the way down the page.

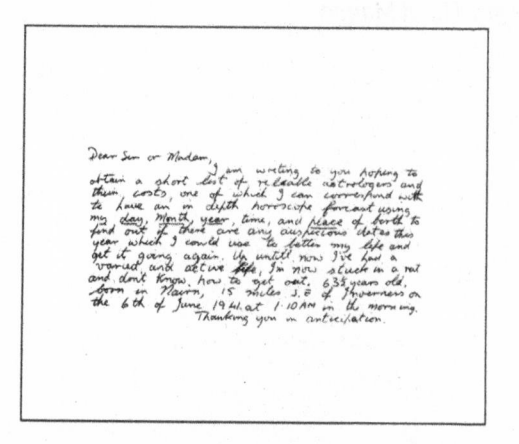

All-Around Wide Margins

People who present their writing with clear equally spaced margins all around are those who wish to be clearly understood. They may have a commercial background with an aesthetic

sense; possibly they are sensitive individuals who like to use artistic license. If the space is very large, the writer can almost be a recluse.

No Margins at All

Individuals who leave no margins around their writing can be economical and thrifty to the point of meanness. This trait can also show that the writer has no artistic sense. An individual with this tendency may have a gregarious nature and a need to be loved and wanted; he or she may be a compulsive talker who lacks tact and diplomacy. This writer can cling to past relationships and be unable to let go of past hurts.

Narrow Upper Margin

Writers who use narrow or no upper margins can show a dislike of formality and a lack of respect; this characteristic can also indicate ambition. Writers who use a narrow upper margin display little or no planning skills. They can be pessimistic individuals with little or no artistic abilities; they may have a poor educational background. Young people often use narrow upper margins.

Large or Wide Upper Margin

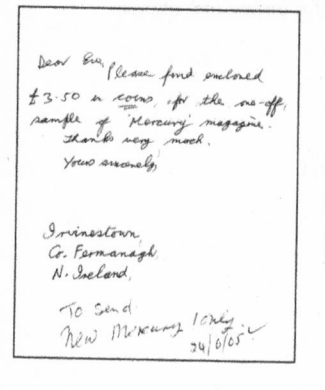

A wide margin left at the top of the page can indicate that the writer has low self-esteem. They may be overly respectful toward their employers and elders. They tend to live in the present and may have little thought for the future.

The Envelope Layout Margins

The envelope is divided into four areas: upper, lower, right, left.

The Address Written in the Center of the Envelope

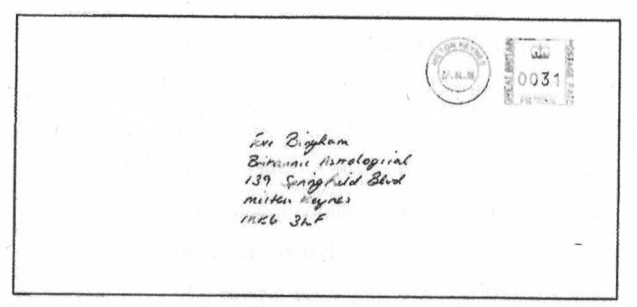

Writers who place the address in the center of the envelope indicate that they are clear thinkers with the ability to organize. This positioning can also indicate that they are orderly, caring, and considerate of others. Underlined words or phrases show that the writer is fussy and easily worried.

The Address Written to the Far Right of the Envelope

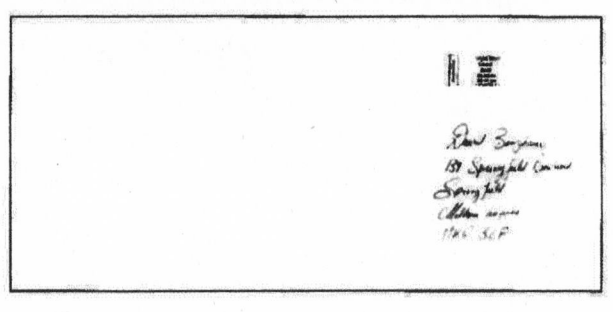

An address positioned to the far right of the envelope, sometimes with heavy pressure of the script, can indicate an impulsive person who has aggressive tendencies but who also needs the company of others.

The Address Written at the Top of the Envelope

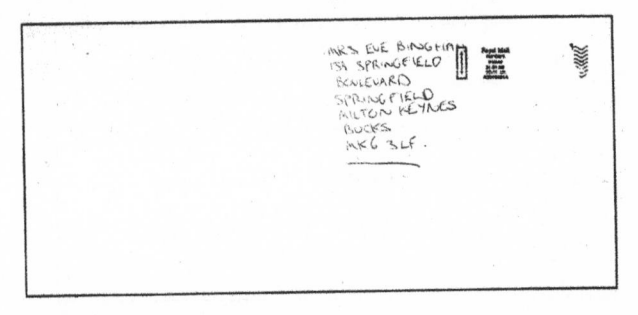

The placing of the address at the top of the envelope denotes that the writer is enterprising and has the need to express his or her opinions. If only the upper half of the envelope is used, the writer can be immature and prone to daydreaming. Sometimes, a young person who forgets that an area for the stamp needs to be left open writes like this.

The Address Written Very Low—Center or Left Position

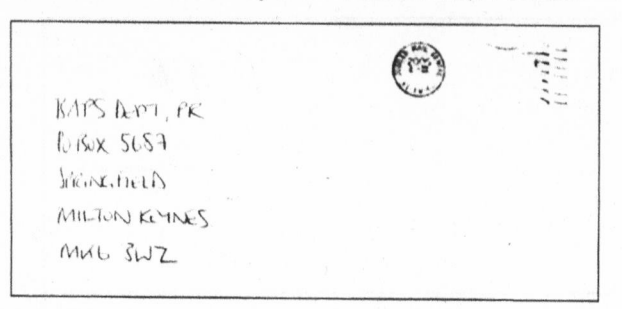

An address in an extremely low position, whether it is placed centrally or to the left on the envelope, can indicate anxiety and a pessimistic outlook on life. This positioning can also show a materialistic streak.

No Space Around the Address

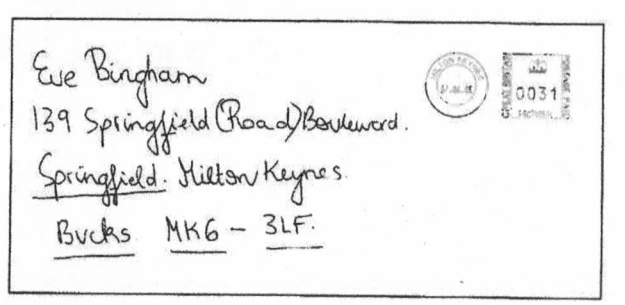

The writer who leaves no space on the envelope shows a need to participate in all aspects of life. Usually, the writing is extremely large, indicating a person who tends to want to be noticed.

The Address Written to the Left and Center of the Envelope

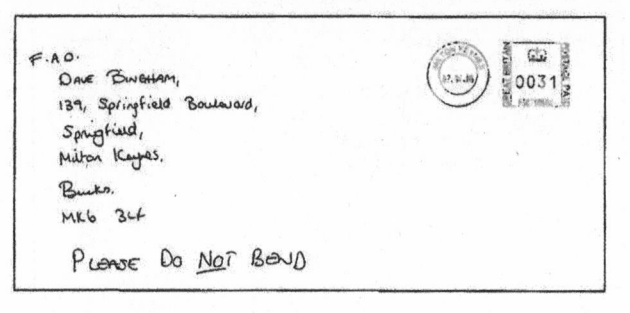

The individual who addresses an envelope to the left, centered vertically, can be afraid of life and may also be reserved. This person's interests are more with inanimate objects than with people.

The Address Written in the Bottom Left-Hand Corner

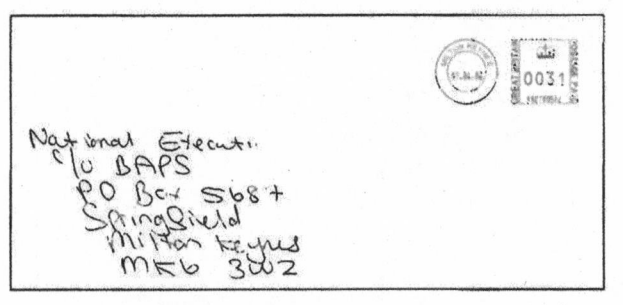

Placement of the address in the bottom left-hand corner of the envelope is unusual, but those who do position it here may have very small writing, showing a lack of confidence and an inner need for security.

The Address Written In the Upper Left-Hand Corner

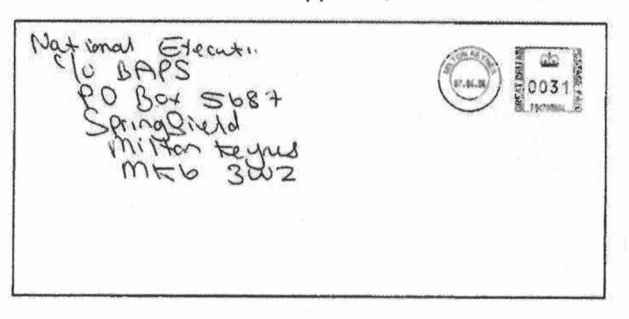

An address placed in the upper left-hand corner of the envelope denotes a writer who can be an intellectual but is very much a loner.

The Address Written on the Envelope Is Staggered

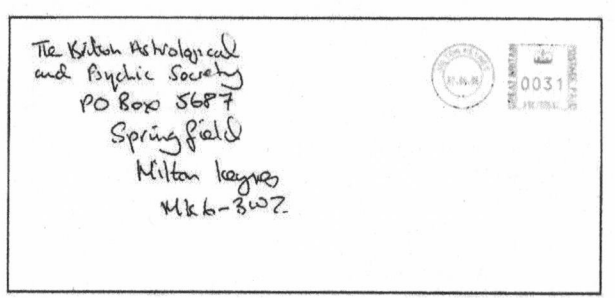

A person who has staggered the address, progressing from the top left to the bottom right, has a cautious and inhibited nature.

The Address Is Extremely Small and In the Center

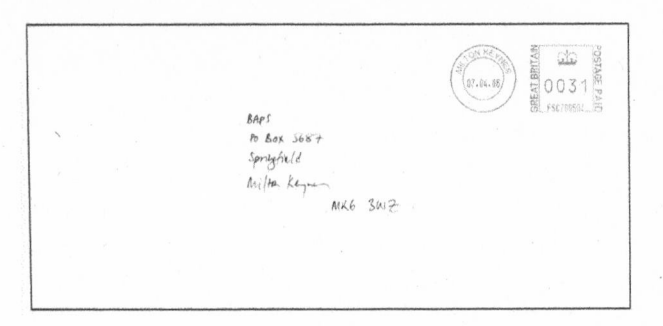

An address placed in the center and written extremely small indicates that the writer puts his or her own needs before those of others.

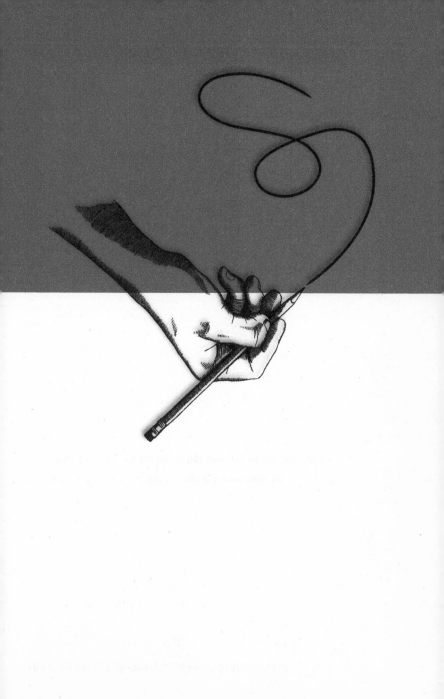

Slants: Emotional Interaction

3

It is important to remember that the more indications you discover in a person's handwriting, and the longer the writing sample is, the better you will understand the writer. There are three basic slants to handwriting: the right-handed and left-handed slants and the upright slant. On occasion you may find a mixture of these.

A graphologist friend of mine has a novel way of remembering the slant indicators: Imagine three people who want a cup of tea. The writer with the left-hand slant would delegate someone else to make the tea, the writer with the upright slant would make him- or herself a cup of tea, and the writer with the right-hand slant would make everyone a cup of tea. We will now look at the various slants in handwriting and see what the differences indicate.

The Right Slant

The right-leaning slant is found in the majority of people's handwriting. This most common slant can show a forward-looking person with a friendly disposition who enjoys human contact and who likes to be surrounded by others. People who display this characteristic have well-developed social instincts and may forget themselves in their interactions with others. These people are sociable and responsive, with good coping abilities. They can

Could you please forward me a list my Surrounding area, as I would

Right-leaning slant

be demonstrative and like to show their feelings. The person with a right-handed slant can be extroverted, outgoing, and friendly, and has forward-thinking spontaneity and enthusiasm.

An exaggerated slope to the right indicates that the heart rules the head and the individual is emotionally motivated. This writer can be irresponsible, gushingly sentimental, sympathetic, and embarrassingly demonstrative. This person can be impulsive, has a need to relate to others, and can overdo everything so that he or she becomes physically exhausted.

Some positive keywords

active
adaptable
affectionate
curious
emotional
enterprising
progressive
sociable
sympathetic
trust in the future

Some negative keywords

accident-prone
easily distracted
excitable
forgetful
gregarious
gullible

hasty

hysterical

lack of discipline

too demonstrative

wasteful

The Vertical or Upright Slant

The upright script indicates an independent person who is dominated by reason rather than emotions. People who display this trait are able to see both sides of an argument and they usually stay neutral. The closer the letters are to being upright the more control these writers have over themselves. Completely vertical writing is a sign of poise, calm, self-reliance, and a neutral attitude to most things. These are mature, practical, and independent people whose heads rule their hearts. They can be self-sufficient; they have low emotional responses, and they can be restrained. These writers will not make a drama out of a crisis and they can be relied on in an emergency situation.

a hot stove, you

Vertical or upright slant

Some positive keywords

an ability to concentrate

analytical

cautious

diplomatic

good self-control

impartial

independent

mature

prudent

reliable

reserved

Some negative keywords

critical observation

inactivity

indifference

lack of emotional response

a pessimistic outlook

self-centered

The Left Slant

People whose handwriting slants to the left may be inclined to daydream, living an active inner life. They tend to be shy and reserved, and they are socially cautious. They can be observant, though, and can be good listeners. They are self-reliant, and they don't intrude on the privacy of others. Someone who writes with

for that book. I would have come however - unfortunately there was

Left-leaning slant

a left-handed slant, depending on the degree of slant, may have had a dominant mother figure during childhood. Perhaps the father was a weaker character, or possible he was totally absent. Such writers find comfort in behaving in an unconventional way and some find it hard to cope with change. If their handwriting displays an exaggerated left slant, they can have a morbid curiosity about death, may suffer inner rebellion, or they may be emotionally repressed.

Some positive keywords

persistent

sentimental

tender and devoted

Some negative keywords

curbed spontaneity

fear of commitment

forced behavior

fussy

insecurity

insincerity

living in the past and fearing the future

obstinacy

overcautious

pedantic

selfish

Varying Slant

Writers who have fluctuating and varying slants show versatility and an erratic streak; they can be impatient, intelligent, and highly active. This is also the writing of an unpredictable individual with changing behavior patterns who can experience mood swings and self-conflict. People with this handwriting characteristic like to mix and communicate with others; they enjoy variety and change in their lives; and they can be happy-go-lucky characters. This type of writing is often found in teenagers when they are unsettled, with all kinds of conflicting thoughts and ideas, and a need for social and emotional acceptance, and more independence.

"Journey of a Lifetime" Project, with the help of members of the Johann Strauss Society.

A variety of slants

Some positive keywords

adaptable

friendly

intelligent

versatile

Some negative keywords

inner conflict

neurosis

unpredictable

unstable

So far we have considered the slant of the writer; and knowing that a signature represents our public image, the way we write represents how we are feeling privately. Let us apply this concept to a few cases. You may wish to refer to chapter 13, "Signature: The Public Image."

Writing Slant and Signature Slant

Left slant with right slant signature

Individuals who write with a left-handed slant but whose signatures have a right-handed slant value their privacy. They are reserved individuals who give the appearance of being outgoing. You can be sure that inside they are not nearly as spontaneous and outgoing as they appear to be.

Strong right slant writing with a vertical signature

Writers with a strong right-hand slant and an upright signature can have intense personalities, but they give the impression of being analytical and reserved. They have learned to control their intense nature in the public eye, but as you get to know them a little better, you will get to see this other side of them.

Small vertical writing with large right slant signature

An individual who has small vertical writing but a large right-slant signature has an analytical mind, displays good attention to detail, has an image of a commanding presence, and has good interpersonal skills. Although people with this handwriting appear to be outgoing and socially very comfortable, inside they are reserved and private.

See how easy it is to combine handwriting traits to understand people better? Remember, we are looking at only a few traits, and there may be other aspects of an individual's handwriting that need to be included. Each trait is a piece of the picture!

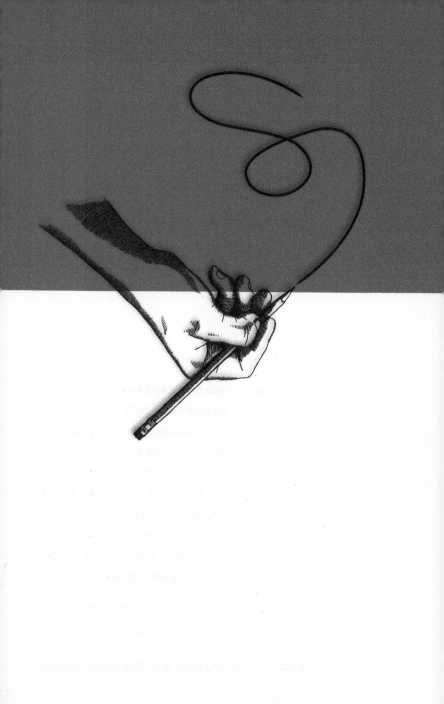

The Three
Zones of
Expression

4

The three zones of expression are the upper, middle, and lower zones. Where there is a lack of proportion or equality among the different zones, the dominant zones will point to the writer's overenthusiastic response in that area. Ideally, all three zones of handwriting should be balanced, showing a well-proportioned script; this scenario signifies the individual who is capable of leading a balanced life.

UPPER
MIDDLE
LOWER

The Upper Zone

The upper zone is the area that is covered by the stems of letters such as the lowercase letters d and t and all the capital letters. The upper extensions of the loops of the lowercase letters b, f, h, k, and l can be written in varying degrees of size and height. The top or upper zone reveals idealism, spiritual aspirations, ambitions, and intellect, plus the practicalities of life.

The maturity of an individual can be seen in the size of his or her writing in the upper and lower zones: the mature writer shows no exaggeration in either zone.

Loops too high in the upper zone

If the loops in the upper zone are too high, the individual may be aiming too high in his or her search for perfection, and the subject's idealistic qualities can lack realistic purpose.

has been

Loops too small in the upper zone

Too small or nonexistent upper loops can be *address letter address of* an indication of being too matter-of-fact and may suggest a lack of goals in life; this trait also indicates that logic and intellect take priority over emotion.

Oversized loops in the upper zone

The writer of oversized upper loops displays a muddled mind, an exaggerated ego, and a *To focus* tendency to show off and demand attention. This trait can also reveal an individual who shows signs of fantasy and of being a daydreamer; this writer can substitute the imaginary world for reality.

Upper loops repeated in the upper zone

The person who retraces upper loops several times is revealing signs of insecurity and an *Kindly send Register* indication of neurosis. He or she needs to make achievements but may be unable to do much or may be afraid to go forward for fear of making mistakes. This trait can also symbolize the gap between achievement and aspirations, particularly if the loops are oversized.

Thin and narrow loops in the upper zone

find my new address above.

If the upper-zone loops are too lean and narrow, the writer is either frustrated and restricted or perhaps too rational in his or her thinking. There can be religious leanings, or the absence of

physical contact, and a lack of warmth within the family circle when the writer was a child, which prevents the individual from expressing his or her feelings. Thin and narrow loops are an indication of a lack of forward vision, a lack of perception, and stunted warmth.

Fuller loops in the upper zone

could you provide

Fuller loops in the upper zone indicate that the writer is imaginative, friendly, affectionate, and loving. This trait can also reveal liberal sentiments and emotional responses; individuals with this writing style like to express their feelings within friendships and close relationships.

Loops sloping to the left in the upper zone

they are not all of them
some I have thrown in,
the waste paper bin

The writer who displays loops sloping to the left of the page within the upper zone can be showing an active inner life, including the traits of contemplation and a tendency to brood on memories and experiences. This writing shows introverted tendencies.

Loops sloping to the right in the upper zone

they are not all of them
some I have thrown in,
the waste paper bin

Loops that slope toward the right of the page within the upper zone can indicate intellectual ambitions. The person who shows this writing trait has a lot of drive and energy, with the desire to use his or her mental abilities in a constructive way. The individual whose writing slopes to the right is usually an extrovert.

Fluctuating sizes of loops in the upper zone

loads of love

A handwriting sample with a variety of sizes displayed in the loops of the upper zone, sometimes fluctuating in length and width, can reveal the writer's tendency to vary his or her moods. This individual's ideas and ambitions suffer accordingly, and he or she may be optimistic one day, pessimistic the next.

The Middle Zone

The middle zone of handwriting reveals whether the writer is a "thinking" or a "feeling" type of person. Letters within the middle zone show whether the writer offers warmth and affection in relationships or prefers to take an analytical and logical approach. This zone can also show the social attitude of the writer.

The middle zone is the area where all lowercase letters without loops are formed; it represents a balance between the upper and lower zones. All lowercase letters should be written at the same height.

The middle zone concerns social life, the emotions, practical behavior, and everyday life. It can show the things that motivate the individual. It shows how someone adapts to circumstances both on a mental and emotional level. Children's writing has a large middle zone.

Very large writing in the middle zone

A very large script in the middle zone shows that the writer can be self-absorbed; although this individual can be socially outgoing and friendly, he or she can also be egotistical. Such writers might overreact to people and events. Someone whose writing is large in the middle zone area can be generous and extravagant. This trait also shows that this writer can enjoy him- or herself on a grand scale, to the extent of going over the top. Although apparently confident, this person might actually be hiding self-consciousness. Inflated or exaggerated middle-zone writers tend to be somewhat immature in their emotional attitude and can be highly sensitive to any form of personal criticism.

Large writing in the middle zone

last communication

Large middle-zone writers are aware of other people and thrive on being the center of attention and in the thick of a social gathering, such as a party. They love attention and dislike being in the background. Also, a capital letter inserted in the middle zone indicates that the writer seeks acknowledgement and has a desire for recognition. Occasionally, such a capital letter appears in the handwriting of artistic or creative people who want to appear more clever and interesting than they really are. The capital letters that occur most frequently in the middle zone are R and M.

Small writing in the middle zone writing

Would it be possible
you to send me some

Writers with a small middle zone are thinkers who use an analytical approach to solve the problems of love and life. Such writers usually keep their emotions in check and do not tend to act impulsively or rashly. These people are usually happiest being observers, and they can be less spontaneous than most in their friendships. They tend to hold back on introductions and they do not always trust people.

The Lower Zone

The lower zone is the area where the traits of physical health, sexual drive, materialistic concerns, and instinctive behavior are seen. This zone is where you find the lower loops of the lower-case script letters f, g, j, p, q, y, and z. Here the personality traits are governed by the length and width of the loops.

The lower zone in handwriting reveals the sexual instincts of the writer; the way the lowercase letters g and y are formed gives the clues to the writer's attitudes and preferences. Whether these letters are written with or without loops, with heavy pressure or light, can reveal quite a lot about the writer's materialistic drives and energy levels. The correct way of writing a g or y is to bring the stroke down, around, and up, crossing over to form a loop.

There are many variations of the loop, and this is where the signs of inhibition, vanity, sensuality, sexuality, and materialism are revealed.

Long, rounded loops with pressure in the lower zone

A very long, rounded loop with plenty of pressure within the lower zone is a sign of energy and drive, but also strong sexual inclinations and a need for the writer to express them. This can also show that the writer is fond of playing sports, especially team games.

Thin, wavering slopes in the lower zone

A thin, wavering down stroke or loop in the lower zone indicates a lack of vitality, energy, or interest in life.

Short, rounded loops in the lower zone

A loop in the lower zone that is short and full with a round base shows a love of flirting and an affectionate and loving nature, but not necessarily a sensual or sexy one. This type of writer will probably enjoy the chase much more than the capture.

Inflated loops in the lower zone

An exaggerated g or y in the lower zone with an inflated loop shows that the writer can be boastful; this trait can also indicate an inflated ego. Writers with this trait are apt to brag about their sexuality, and they love to be the center of attention. Often they are compensating for an inferiority complex, and their feelings are superficial and are not supported by a great deal of action.

Loops leaning to the left in the lower zone

Loops leaning to the left in the lower zone

of my mind
of age I just

Loops leaning to the left in the lower zone can indicate a mother fixation. This trait is often seen in the writing of men who find it hard to establish relationships with the opposite sex. This trait can also indicate a person still living at home, probably looking after a mother or caring for an elderly person whose health is poor.

Loops leaning to the right in the lower zone

In my area

Loops in the lower zone that lean to the right are an indication of a strong father influence in the writer's early and formative years.

Lines instead of loops in the lower zone

Keeping together

A simple line rather than a loop within the lower zone reveals good concentration skills and business acumen. It can also show a tendency to neglect instinctive drives or intuition. This writer channels a lot of energy into work and career, inhibiting natural emotional needs.

Long, unlooped downward strokes

A long, unlooped downward stroke is an indication of an interest in psychic subjects and psychology.

Regards
Gladys

The
Baseline

5

The baseline is one of the most important areas of handwriting. We are instructed as children to observe the baseline and to write in straight lines. The reality is, however, that even after years of practice, few people can actually write in a straight line on unlined paper.

The baseline shows how well an individual is handling stress at the time of writing and it can be an indicator of the writer's mood at any one time. Deviations from writing in a perfectly straight line are normal.

Normal Straight Baseline

I think being a parent. is a very hard job especially to teenagers,

People who write with a normal, straight baseline are reliable and determined individuals who are self-motivated and self-controlled. They are orderly, methodical, and responsible and have strong minds that control their emotions. A person who writes in a straight line is not usually deterred from his or her aims and goals. If a person writes precisely in a straight line, then we may say that person is unyielding.

Ascending or Rising Baseline

send me your brochure on astrology courses etc,

Baselines that ascend in steps are often found in the handwriting of those who have little stamina. Writers of this type of baseline

are usually optimistic and ambitious and have a positive attitude; they are willing to cooperate with others, and they tend to emphasize the positive view. They have a strong response to new ideas.

Descending or Falling Baseline

A descending or falling baseline usually indicates someone who is over-worked, suffering from

Best Wishes to you all for the New Year

fatigue, or has too much to do in a short space of time. Tired and overwhelmed, this individual tends to have a pessimistic attitude and can be depressive. A baseline that descends in steps is often found in writers who bravely fight off depressive moods. This trait is also found in an older person's writing, and can indicate ailments such as arthritis or osteoporosis, or depression, fatigue, and grief. Aching bones and arm muscles that become weak and drop toward the body cause this writing.

Wavy or Erratic Baseline

Please can you send me a copy of your prospectus I am from

Wavy or erratic baselines may be indicative of moodiness. Teenagers often write with this kind of baseline when they are unsettled, with their minds and moods all over the place due to hormonal changes and a lack of definite direction in life. People who write with an erratic baseline can be emotionally unsettled, unpredictable, unstable, and indecisive.

Spacing

6

Spacing is a little more complex than other facets of hand-writing. The following guidelines regarding spacing are based generally upon accepted principles of graphology. As with all other traits and indications in handwriting, spacing must be considered in relation to other factors in the handwriting sample. There are three basic elements of spacing relating to handwriting: spacing between the words, spacing between the letters, and spacing between the lines. The distance between the letters and words is difficult to alter at will when an individual is writing at normal speed. Spacing between the lines, however, is a matter of choice, which a person with average mentality can alter when writing at normal speed. For reasons of available space or personal taste, therefore, the amount of space that appears between the lines is likely to be an indication of conscious preference.

Spacing Between Words

"Cursive" is another word for running script or joined-up writing. Good handwriting is based on a pattern of parallel lines and ovals. Normal spacing between words should be a gap the size of one lowercase letter o. A capital letter should start on the baseline and reach no higher than the top of the loop in a lowercase letter such as an h. A letter that finishes in the upper part of the middle zone should join the next letter horizontally, and a letter finishing in the lower part of the middle zone should join the next letter diagonally.

Word spacing can be related to the way in which we speak. When a person speaks with intermittent pauses, it may be because he or she is accustomed to pondering and considering

before acting. It can also be because the person wants to let his or her words be understood by the listener. However, if the pauses outweigh the importance of the speech, then we may conclude that the speaker is conceited.

Even spacing between the words

The spaces between words can reflect how a writer relates to others. If the spacing is neat and even, the writer usually enjoys the company of others and tends to have a genuine concern for his or her fellow human beings. The writer whose handwritten script is regular and flowing normally leaves the correct amount of spacing between the words; the writing is neither too crowded nor too far apart. Most secretaries leave the correct spacing between words in their handwriting, having used a typewriter or word processor for many years.

Wide spacing between the words

Wide spacing between words is an indication that the writer is not too friendly and prefers his or her own company. These individuals need privacy and distance from others. Widely spaced words are associated with intelligent and independent leaders. These writers take time and effort to think through problems carefully before they make a decision. Individuals with this style

of writing can be critical and argumentative. When a writer's words are sometimes widely spaced and at other times narrowly set apart, then we may say that this individual is unstable in both thinking and emotions.

Little space between the words

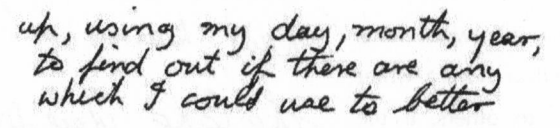

A person who writes with little spacing between the words may have a lot to say for him- or herself but says little of any importance. If there are no spaces between the writer's words, this is indicative of a person of action. This person can also be impulsive. He or she may seek constant contact and closeness with others and have strong feelings of insecurity. The writer can also be introverted and self-conscious and suffer from personal inhibition.

Spacing of Letters within Words

Long joining extensions

I understand An individual who writes with long joining extensions within words shows a lack of inhibitions and is usually an extrovert. These people are considerate and sensitive to those around them. It is important, however, that these writers have time to themselves because they are generous and open-minded but often find it difficult to say no to friends and family, which can exhaust their own energies.

Narrow or irregular spacing

Close and irregular spac-
ing within words is indica-
tive of a person who can
talk nonstop on his or her

what is happening! to set any markings

chosen topic. This trait often is characteristic of people who are
impatient but loyal. These individuals are practical and logical
and can have good organizational skills. They can be specialists
in their chosen field of work, but they have few interests out-
side their careers. Writers whose letters are all narrowly spaced
within the words are usually introverted and cautious. They gen-
erally lack faith in their own abilities. Indeed, when they are in
love, their insecurities can mean that they are prone to jealousy.
Writers of this type of script can display self-consciousness, inhi-
bitions, and introversion. Some of these individuals have a fear
of loneliness and crave contact with people but have little or no
respect for the privacy of others.

Spacing Between Lines

The space between the lines is most probably deliberately
planned and can be described as the picture of the writer's mind.
Lines of writing should have enough space between them so the
upward and downward strokes do not touch.

Large spacing between the lines

A person who writes with widely spaced lines may be said to
live an ordered life. These people have executive ability and

What is happening !

to set any markings

are reasonable in their thinking. If the space between the lines becomes too large, however, it may indicate that this is a person who likes to keep his or her distance. Large spacing between the lines can be an indication that the writer is out of contact with others. Individuals who write this way desperately need love and affection, but they are afraid to get too involved in an intimate relationship for fear of getting hurt. This can also be due to a fear of failure in a shy, withdrawn, and emotional person. This spacing can also be indicative of writers who are out of touch with the realities of everyday life. Although they can be distrusting of others, they fear isolation. The distance between the words indicates the extent of this person's solitude.

like some of your booklets and information on your courses

Normal spacing between lines

Normal or "copybook" spacing between the written lines belong to someone who thinks clearly and who has inner balance and harmony, sound judgment and a sense of proportion.

Cramped spacing between the lines

up, using my day, month, year,
to find out if there are any
which I could use to better

Small spacing between the lines may indicate a person who likes to be around other people. Script with cramped spacing between the lines, with the bottom loops on one line mixing with the upper loops of the next line, is an indication of a person with a muddled mind who needs contact with others. This trait is also an indication of confusion for this writer, who lacks perspective and has poor judgment.

Connecting
and Forming
Letters

7

The way we connect the letters in script, or fail to do so, can reveal the way we think and our attitude toward others. It can also tell us whether we rely more on the logical mind or on intuitive faculties when finding solutions to problems. The two factors that need consideration are the way that letters are formed and the way they connect to one another.

The connection and formation styles fall into six categories: copybook, arcade, angular, garland, wavy-line, and thread-like. There are also four common letter styles: artistic, artificial, simple, and copybook. The degree of connection between letters takes two forms. In the first form, most of the letters are joined together to form a continuous active movement, which promotes a fluent and lively pace. In the second, the letters are joined in varying amounts and ways.

Connected Letters

Lave been told to

People who write with "joined up" letters are logical and well organized. They see the logical order in which to do things and they solve problems in a practical manner. Their conversation flows easily and they mix well with others because they understand relationships. Some people go the extreme of joining up actual words as well as letters because they don't want to lose their train of thinking while they are writing. Such people may find writing something of a strain.

Some positive keywords

adaptability

consistency

deductive thinking

good memory

logical mind

sociability

Some negative keywords

inclined to reach hasty conclusions

inconsiderate

superficiality

Disconnected Letters

information and an

In disconnected script, usually no more than three letters are connected to each other in one word. This type of handwriting can point to a thought process influenced by intuition or to a lack of concentration. The writer who does not join letters concentrates on details rather than the whole project. This type of handwriting might be typical of a supervisor who ignores all that you have achieved but picks on the one mistake you've made. This trait can also indicate a writer who comes up with original ideas. Those who write with a disconnected script are influenced by their intuition and they find it difficult to ignore. These writers prefer to keep their distance from others. They can put a barrier

around themselves and do not like the close company of others. Because they choose to behave this way, they can suffer loneliness, but they do not display it. These imaginative people channel their inventiveness into an artistic outlet.

Some positive keywords

artistic

cautious

creative

imaginative

independent

individualistic

intuitive thinkers

inventive

musical

self-reliant

Some negative keywords

lack of forethought

lonely

moody

stubborn

uncooperative

unreliable

unsociable

Forms of Connection

There are six basic letter formations in graphology: copybook, arcade, angular, garland, wavy-line, and threadlike. Each of these styles reveals a different personality trait, and these styles are of great importance within handwriting analysis. When in school, we are taught to join our letters with rounded "copybook" connections. Some people retain this particular style, but others find their own connections. The writer's own individual personality is revealed within these formation styles.

Copybook style of script

send me an up to dat

Copybook style is taught rigorously in schools. It is the style of more conventional writers, those who have not, as yet, developed a way of thinking for themselves or a personality beyond that of their school days. These writers feel safe by conforming to prescribed and accepted patterns of thought and structured behavior with little or no originality. Some people writing in this style may come from a poor educational background.

This style is rarely used alone because it usually appears within a mixture of styles. It can be used deliberately, for the purpose of disguise (as in anonymous letters). Nuns, nurses, priests, and devoted teachers can write in this way, but don't forget that this style can also hide criminal tendencies.

Some positive keywords

conventional

predictable

Some negative keywords

> criminal tendencies
> deliberate
> lack of originality
> not easy to motivate
> orthodox habits
> slow

Arcade connections

please send me details

The writing of someone who uses the arcade style of script is humped and rounded at the top of the middle zone. The writer of arcade-type script shows a more formal way of styling letters and this indicates that he or she has a traditional sense of values. These individuals are not ones for making instant friendships, as they like to evaluate situations and people before committing themselves. An individual who uses arcade script often is creative; possible tendencies are toward musical talent or having an eye for shape and color. People who write in this style prefer to keep their own counsel and rarely let others know their true thoughts and feelings until they know them well. These writers can mix and communicate well with others when necessary, although they like to keep their personal lives private.

Arcade writers can be staid in their ways and rigid in their thinking. They have their own set of rules from which they operate, and nothing can deter them from their way of doing things,

which is the conventional way. Teachers often have this type of writing, as do architects. The m's and n's within the script can be arch shaped.

Some positive keywords

cautious

confidentiality

constructive conventionality

formal manners

loyalty

retentive memory

security

trustworthiness

Some negative keywords

close-minded

distrustful

hypocritical

lack of personality and imagination

secretive

stubborn

Angular connections

Angular connections in the middle zone show an analytical mind; the sharp points give the impression of probing. The angular writer is persistent and he doesn't back away from difficult tasks.

Individuals with this style of writing have an intelligent approach and self-discipline, and they are willing to work hard in a situation that needs constant attention to detail. The writer whose script is angular displays individuality; the lines are sharp and sometimes even pointed, particularly the tops of the lowercase m's and n's.

People who use this style of writing are shrewd individuals who have a practical and down-to-earth approach. The writer of angular script is critical of others, and if the writer also presses down hard on the page, this can be an indication of aggression. These writers are observant people who are able to concentrate on details. People with large angular writing can be self-centered and possibly lack tolerance for the opinions and ideas of others. An individual with the angular style of writing can be prone to cutting remarks without thought for the other person's feelings. This writer tends to learn by his or her own mistakes.

Some positive keywords

creative thinking
determined
ethical
hardworking
objective
reliable

Some negative keywords

argumentative
conflict
cruelty

hard

irritable

lack of compromise

obstinate

resistant to others' ideas

sadism

sharp

tense

Garland connections

can you send me

Garland script is easily and quickly formed and is usually the script of people who are prone to laziness. They are, however, kind, friendly, and affectionate individuals who do not have aggression in their nature; they prefer harmony to friction in their lives. These people like an active social life and they enjoy the company of friends and family. This person is an excellent host who enjoys entertaining on a grand scale. The person who uses the garland style of writing is also a "Dear Abby," to whom people are drawn in order to pour out their troubles. People with this writing style are expressive and cooperative and are usually at ease with most people and the environment; they normally avoid conflict. These writers are not competitors; they will compromise by taking the path of least resistance. Some of these individuals are open to emotional influence and can be gullible.

Some positive keywords

adjustability

friendliness

kindness

lack of formality

optimistic outlook

receptiveness

Some negative keywords

complacent

connections and formation

gullible

laziness

tactless

talkative

thoughtlessness

weakness

Wavy-line connections

to have fun and learn to

Writers who use wavy-line formations need freedom to adapt to circumstances and the environment. They do not easily commit themselves fully to any event; they prefer to keep their individuality without obligations. Their thinking is usually flighty and subjective, and they have no definite goals or pattern in life, preferring to ebb and flow with the tide.

Some positive keywords

diplomatic

freedom loving

go with the flow

Some negative keywords

avoiding commitment

two-faced

Threadlike formations

The threadlike formation is like a length of thread laid out on the page, rather than letters being formed, as there is no real letter

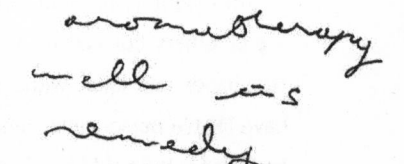

definition in the writing. Threadlike script is indicative of excellent manipulating ability. These people are mentally alert and difficult to pin down, and others find them particularly difficult to understand. These restless and elusive writers can sometimes be inconsistent. They hate to be tied down to one course of action and like to be free to do their own thing rather than follow any set, structured routine. These individuals can understand other people and have an aptitude for getting their own way without too much trouble. The positive traits associated with this type of writer are that they are quick thinkers and intelligent individuals. On the negative side, these writers can be secretive, they may change facts to suit their own ends, and they can be confused.

The threadlike connection style is, in some instances, almost illegible. This style is often found at the end of a word that ends with -ing, which can be written as one final downward movement. Writers who use the threadlike formation have very strong instincts for self-preservation and they can adapt to any situation, provided it is to their advantage and without loss to their own individuality. If they do not have the freedom to pursue their creative abilities, they will balk at any confined convention. However, they prefer to follow a trouble-free path and avoid restrictions.

These writers have an instinctive, spontaneous understanding of others but can manipulate people to follow their own commands and ideas without being overbearing, and they do have likable personalities. People with this style of writing can be found in the field of psychology, where their strong powers of observation stand them in good stead. They can view both sides of a situation and give advice without being drawn into the situation themselves.

Another type of threadlike connection occurs when the thread is within the word; this connection can appear in any part of a word, and sometimes even throughout the word. In the most negative form of the threadlike connection, a word can be written as one letter followed by a line. Thread writers are indecisive and unsure of themselves, which leaves them open to influence. They find it difficult to cope with external pressures, which they find stressful. These people can be creative but prefer to learn by experience rather than formal training or teaching.

Some positive keywords

agile mind

broadminded

individual ideas

need for freedom

reliant on instinct

self-aware

versatile

Some negative keywords

avoid aggression

feelings of insecurity

hysterical

impressionable

unstable

Forms of Letters

There are four basic styles to the forms of letters: artistic, artificial, simple, and copybook. Some writers can reduce their basic form to the point of neglect, while others overemphasize with flourishes and embellishments. To be analyzed correctly, the sample of script should be legible, original, and spontaneously written.

Artistic form of letters

yours faithfully

Writers who form artistic letters are usually intelligent and naturally artistic. They add ornamentation to their script but retain legibility by the natural way they form their letters.

Artificial form of letters

All The Best,
Love,
From

Very florid and highly adorned and stylized script can belong to a person who is trying to hide an inferiority complex or to give the impression of being artistic or talented, while actually being nothing of the kind.

Simple form of letters

my new address

Writers who produce script that is stripped down to the bare essentials but that still retains legibility have active minds and aesthetic awareness.

to view a house,

These writers prefer friends with whom they can have deep, meaningful discussions, and who can share their interests and intellectual interactions. Such writers can cut corners and simplify tasks to save time and effort. These writers would be unreliable in a situation that demands their concentration on minor details, as they would find it boring and become restless.

Copybook form of letters

He wanted to be a public servant.

While this style of writing is "correct," there is little individuality, so writers using this form are lacking in imagination and originality. These writers are difficult to motivate; however, they are reliable in situations that require repetitive activity, and they are content to stay within imposed restrictions, as their minds require little stimulus.

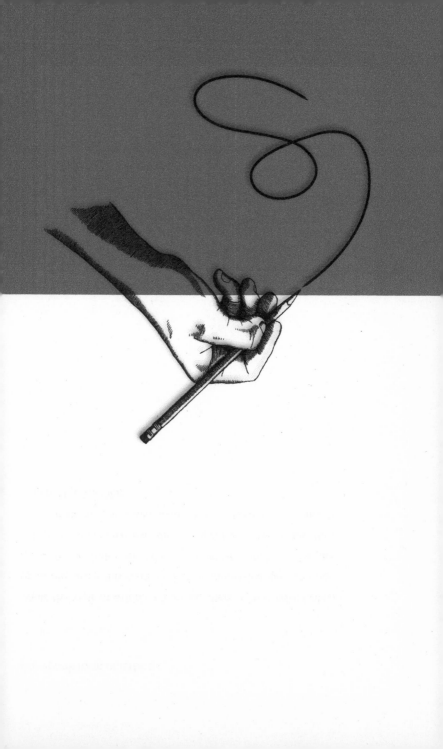

Beginning and Ending Strokes

8

The strokes that are made by the writer at the beginning and at the end of each word need to be taken into consideration in any handwriting analysis, as this trait indicates the amount of preparation, if any, that this person requires before going into action. Whether the script is unnecessary or constructive will reveal whether the writer is likely to finish the task at hand.

The Initial Strokes

As we were taught in elementary school, the writer creates the initial stroke at the beginning of each word written.

Long initial stroke on letters

Generally speaking, a long initial stroke shows that the writer needs time to make inner preparations before starting anything new. A combination of long initial strokes and a slow pace of writing suggest that the writer is dim-witted. When an initial stroke is fairly long and the speed is decidedly fast, this signifies that the writer gets into the swing of things and maintains the rhythm of activity. A long starting stroke from below the baseline can act as a springboard, but the writing speed must be at least moderately fast for this to be considered a positive factor.

When there is a springboard stroke and the writing is slow, this can indicate that the writer is strongly relating to past ties, to a mother figure, and to the influences of early life experiences.

A fast writer, however, is not affected too strongly by events in earlier years.

No initial stroke on letters

more information regarding your organisation and the courses you

Writers who dive right in to their script without making initial strokes are unlikely to follow set patterns and methods. They are flexible, and they can adapt to whatever circumstances they find themselves in. They are not fussy or careful and they ignore inessential details. They have a positive attitude to life.

Feeling strokes

The feeling stroke is another form of graphic hesitation. In this case, writers *With love* make a few faint starting marks, which may appear as leading strokes, while they are considering their subject and before they begin to write. These writers normally have a copybook style of script. They lack confidence and rarely achieve much because their hesitation and deliberation impede their efforts. The feeling stroke is rare, however, and it usually belongs to those who seldom need to write anything at all.

Hooks

This starting stroke can indicate constructive thinking and persistence. It can also, however, indicate an angry response to interruptions.

week by methods

Initial stroke resting on the baseline

the reviews to be late

When the initial stroke rests squarely on the baseline, the writer will take orders from those who are in positions of authority, follow regulations, and conform to what is acceptable to others. When faced with a decision, these people may feel anxious and inadequate. They usually have a copybook form of script.

The Ending Strokes

The Letter E

1. Shows a liberal attitude to others and to change
2. Has a normal disposition
3. An indication of determination, curiosity, and suspicion
4. This can also be a sign of weakness and timidity

The Letter D

1. This type of d can indicate an aggressive attitude
2. Can also be an obstinate individual who likes to be in control
3. Normal social attitude
4. This can show unemotional tendencies

Most writers end their words with a tailing-off stroke, and these strokes can run from a long stroke to an abrupt ending. These tailing-off strokes relate to an interest in others and they may represent a kind of "reaching out" to others. Therefore, an abrupt ending can indicate a boring person or a lack of energy and drive. The lowercase letter e is the best letter to look at, but the letter d is also interesting, as the writer needs to change direction to produce the end stroke before moving on to the next word.

Pressure

9

There are three types of pressure to be considered in handwriting: heavy, light, and medium. This pressure displays how much energy a writer has and how it is transformed into activity. It reveals whether the writer is a high-activity worker with an emotional nature, or a sensitive, rather highly strung individual with a lack of energy to fall back on. Turn the page over and look at the back and you will soon see whether the writing pressure is heavy or not.

Heavy Pressure

not disappointed

Heavy pressure indicates commitment and taking things seriously, but excessively heavy pressure signifies that these writers get very uptight at times and can react quickly to what they might see as criticism, even though none is intended. These individuals will react first and ask questions afterward. Heavy pressure in handwriting also indicates energy and drive—and sometimes aggression. These writers can be forceful in an argument. They are doers rather than thinkers but can be overemotional. Sometimes they are egotistical, with a strong need for materialistic success. These individuals enjoy eating and drinking, and they can have a high sexual drive. They prefer activity to contemplation and often like to work with their hands.

Light Pressure

Do Consultants.

Light pressure reveals a sensitive personality and mental alertness, combined

with a strong critical streak if the writing is angular. These writers can easily be hurt and may be bruised emotionally. They write with the minimum of energy and are not likely to be active and volatile, but they can be touchy when frustrated in their aims. They dislike unnecessary force or argument and have the ability to adapt to situations with subtle manipulation rather than hostility. These writers are quickly offended by words and often lack tolerance when ruffled; also, they can be sarcastic and irritable. Very light pressure can indicate spirituality, modesty, sensitivity to atmosphere, and empathy toward others, but it shows a lack of vitality. The writer who uses light pressure does not wish to dominate others.

Medium Pressure

Writers who use medium pressure show good balance between intellect and emotion. These writers are usually adaptable, and while they may not be as energetic or highly active as the heavy-pressure writer, they like to strike an even note in life and do not go to extremes. The majority of people use this level of pressure.

Capital Letters 10

Capital letters can give many clues to one's personality and can prove an excellent guide to the ego structure of the writer. The capital letters can reveal self esteem or an inferiority complex. Whether the capital letters are large or small, plain or adorned with flourishes, they can show the writer's true character.

Large Capital Letters

Writers who use large capital letters tend to have an exaggerated opinion of themselves. If the capital letters are three times larger than the rest of the script. writers enjoy being noticed and love to show off and be the center of attention within their circle of friends. This handwriting trait indicates people who are flamboyant and who may think that they are highly sexed. They can be overpowering in social circles, and their desire to impress can cloud their judgment.

Small Capital Letters

Small capital letters are a sign of an introspective nature and a retiring disposition. Individuals who use small capital letters can have feelings of inferiority and may shy away from the limelight,

preferring to be part of the crowd. These writers need to be more assertive and to develop more drive if they are to succeed in life.

Embellished Capital Letters

Writers whose capital letters have lots of twirls, loops, and lines can indicate that they are a little insincere and impressed with the outer trappings of money and possessions. These writers like to have their own way and they find it difficult to see another person's point of view. If their capital letters have extra-long starting letter strokes, these individuals hang on to the past and its experiences, instead of letting go and enjoying newer ideas and adventures. These people find it hard to refrain from clinging to familiar places, people, and experiences, as they are apprehensive of the future.

Narrow Capital Letters

Narrow capital letters at the start of a writer's script can be a sign of thrift or of a strong but rather inhibited nature. These individuals tend to keep to themselves, and others may find them difficult to get along with. These people tend to bottle up emotions,

rarely relax, and usually feel tense. They take life a little bit too seriously.

Rounded Capital Letters

Writers who use rounded capital letters are showing a sense of humor and a nice, outgoing personality. They need to mix and communicate with others and are often found in the center of a crowd. This is because their kind, gentle nature is attractive to others.

Wide Capital Letters

Wide capital letters signify waste, be it of time, money, or energy. These writers have a rather overgenerous nature and like to make spontaneous and impulsive gestures with happy-go-lucky abandonment. These individuals can have a habit of taking the easy way out of a difficult situation.

Angular Capital Letters

People who write with angular and spiky strokes to their capital letters are revealing that they can be sarcastic and they lack flexibility. They have rigid ideas and opinions, and when feeling frustrated or unhappy they can become aggressive. In their

earlier years, they may have had opposition from family, which can have contributed to them becoming prickly and difficult to understand.

Plain Capital Letters

Individuals who write with plain capital letters are intelligent and have good mental processes, with the head ruling the heart. These writers are interested in mental activities rather than physical pursuits. They dislike any kind of ostentatious behavior and prefer simplicity in dress and surroundings.

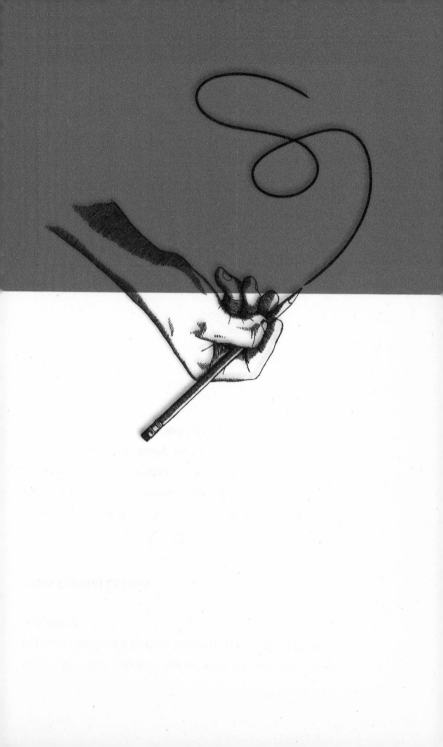

The Ego and "I"

11

The capital letter I has a special significance, and the way that this capital is formed reveals how the writer evaluates the ego. As a symbolic sign of self-esteem or self-evaluation, it can give away as much as the signature can. If the writer is feeling either important and confident or pessimistic and isolated, this will show in the way the capital I is written.

Exaggerated Capital I

An exaggerated capital I shows that the writer is feeling important and slightly arrogant. He or she tends to seek attention and hates to be left out of things. These individuals like to be in charge of any enterprise and have a tendency to show off and to be the center of attention whenever possible, especially with their friends.

Small Capital I

A small capital I signifies pessimism and a lack of confidence; the writer finds it hard to go after the things he or she has wanted since he or she was young. This difficulty may be a result of abuse the person received when he or she was a child. It can also result from a breakdown in an emotional relationship, in which case the small I is a temporary feature. Whatever the reason, this person finds it hard to assert himself or herself.

Straight-Down Capital I

A capital I written as a straight-down line belongs to an intelligent, quick thinker who is able to assess a situation without unnecessary fuss. Emotionally, these writers have excellent

judgment and are able to work out what is important and what is not. These individuals can give the impression that they are cool, but this is not the case. If the capital I swings or leans to the left of the page, there can be a guilt complex preventing the individual from enjoying life. This also shows a writer who is under pressure or suffering a disappointment, which can affect his or her way of thinking and emotions. Letting go of the past can enable the writer to come to terms with these feelings. A capital I that leans to the right can indicate a confident forward-thinking person who reacts quickly to influences, good or bad, and meets the challenges of life head-on.

Circular Capital I

A circular, rounded, bold capital I shows a sense of humor and can denote a sense of the dramatic, although occasionally writers who display this trait can retreat into defensiveness when their feelings become too intense. These people worry about getting into unsatisfactory relationships.

Angular and Spiky Capital I

An angular and spiky capital I indicates that the subject has been thwarted in love and is repressed, so that he or she becomes sarcastic at times, but this individual can have a sharp wit. People who write I's this way are sincere and strong-minded, and their likes and dislikes are soon firmly established. These writers do not suffer fools gladly.

Fragmented Capital I

A capital I that is fragmented shows a love of travel and an avoidance of a restricted living or working environment. Writers who display this trait are often swayed by impulses and spontaneity. They tend to be erratic and undisciplined in both their emotional and social life, but they can be adventurous.

Capital I with a Large Loop

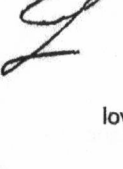

A large loop in a writer's capital I is a sign of emotion. These writers are warm, impulsive, and sentimental; they also enjoy an active social life, although they lean on others for security. The greater the loop, the more affectionate and loving is the nature. This writer is a true romantic.

Capital I with Two Loops

When the capital I has two loops, the writer is guarding against being hurt and seeks harmony. Individuals who display this handwriting characteristic can sometimes be suspicious of others' motivations. An I that is very complicated with two loops shows self-awareness and an analytical mind that likes to unravel problems; people who write their I's this way find an interest in sorting out situations and people.

Printed Capital I

A printed capital I in a person's script can show an interest in literary matters and can indicate some creativity in this direction.

This capital can reveal a love of beautiful things, artistic talent, and a liking for order and method in the life of the writer.

Capital I in Context

Dear Sir/madam,
I'm writing to you

An I that is the same size as the other capital letters in the writer's script suggest that logic and emotions are evenly balanced. When the capital I is a good deal higher than the other capital letters, however, the writer can be a bossy individual who needs to dominate others.

Dotting the i's and Crossing the t's

12

"**D**otting the i's and crossing the t's" is an expression that most of us have heard in some context or other, but in the analysis of a handwriting sample, both these actions are very important. When we are writing, dotting our i's and crossing our t's is automatic; we don't really give any thought to the action.

Crossing the t

The way the writer places the bar across the stem of the letter t can indicate whether the individual is confident, ambitious, pessimistic, cautious, or spontaneous. However, this one indicator is not conclusive; one must also look at all the other indicators. The t bar should be evaluated according to its location in relation to the downward stroke, the significance of rightward and leftward movement, and whether it is placed high or low on the stem.

t bar connected to the following letter

A t bar connected to the following letter can be a sign of writing speed and can denote an intelligent and quick mind.

t bar to the left of the stem

A t bar placed to the left of the stem can reveal caution and a tendency to hold back, particularly when the writer is making decisions. This person is too cautious, so he or she can miss opportunities as a result of this.

t bar to the right of the stem

eat

The t bar that flies away to the right of the stem can indicate an agile mind, impatience, and an emphasis on achieving aims and goals. This indication can be a leadership sign in handwriting and can also show energy and ambition.

t bar sloping downward or upward

must

The t bar that slopes slightly downward can indicate anger under tension, but the t bar that slopes slightly upward on the stem can reveal a basically optimistic individual.

t bar low on the stem

date

A t bar very low on the stem can be an indication of depression, but it can also show excellent organizational skills.

t bar precisely in the middle of the stem

I hated

The writer who places a t bar carefully and precisely in the middle of the stem demonstrates a careful, cautious, and rather pedantic nature. This writer is not given to impulsive gestures or spontaneous acts and may lack forcefulness, but he or she has a generally steady and methodical personality.

t bar at the top of the stem

A t bar at the very top of the stem reveals that the writer may have ideas or ambitions that are not very practical, and this person can also have a tendency to daydream.

Rounded t bar

A t bar that is rounded and full displays the writer's sensitivity and tendency to be impressionable. This writer needs security and affection.

Long, thin t bar

A long, thin t bar that crosses over the entire word can be a sign of protectiveness toward the writer's family and friends, but if it is too forceful and the pressure is heavy, it can mean that this person is intolerant and at times has a patronizing attitude.

Angular t bar

An angular (sharp, pointed) t bar shows that the writer may have suffered disappointment in love and can be touchy under pressure and inclined to be irritable at times.

t bar sharpens at either end

The t bar that sharpens at the end to the right can reveal a quick temper, but a t bar that starts with a point and then gets thicker indicates that the writer is slow to anger.

t bar with tiny hooks

A t bar with a tiny hook at the end or at the beginning can indicate that the writer is tenacious and likes to finish whatever has been started.

Heavy or light t bar

Thoughtlessness is shown in a thick t bar, and sensitivity in a light-pressure t bar.

Knotted t bar

A knotted t bar can denote thoroughness and can indicate that the writer dislikes interference in personal affairs.

Dotting the i

The i dot can reveal caution and reserve, spontaneity and impulsiveness. The position of the dot is extremely important, but it should be considered with a view to confirming other factors revealed in a person's handwriting.

The dotting of the i should be evaluated according to:

- Its location in relation to the stem (the downward stroke)
- The significance of rightward and leftward movement
- Whether it is placed high or low in relation to the stem

i dot to the left of the stem

details

A dot that is placed to the left of the stem indicates caution on the part of the writer. It can also show deliberation before committing to a course of action and hesitation when it comes to making decisions.

i dot to the right of the stem

A dot that is placed to the right of the stem indicates that the writer is progressive and forward thinking and has a practical turn of mind, but this trait can also show reserve.

i dot central but low

A dot that is exactly above the stem but low indicates an individual who has a good eye for detail and an excellent memory, but very little imagination or creative flair.

i dot central but high

Spirit

A dot very high above the stem can indicate a dreamer who may have an inquiring mind but often finds it hard to come down to earth. Such writers also have a rather inquisitive nature that at times can border on nosy impudence.

i dot to the right, slanting upward

find

An i dot that flies to the right of the stem in a slightly upward slant can show ambition, enthusiasm, spontaneity, and lots of vision and activity. This writer likes to be kept busy and rarely wastes time or effort on nonessentials.

i dot as elongated horizontal line

information

An i dot in the shape of a small elongated horizontal line can reveal sensitivity and an impressionable nature. The person with

this handwriting trait can be critical, hard to please, and inclined to overreact against slights—real or imagined.

i dot as an arc

The writer who dots the i in the form of a tiny arc is revealing a well-developed imagination and excellent powers of observation. This particular method of dotting the i can be found in the handwriting of people who deal with creative work or those who are helping others to develop intuition and understanding.

i dot as a circular dot

An i dot in the shape of a tiny circle can show an offbeat sense of humor. Frequently, this trait is found in the handwriting of young girls and older people who have a desire to be thought different and artistic; they can use this as a means of self-expression.

Very heavy i dot

A large, heavy i dot that is racing to the right is a sign of restlessness, impatience, and reaching for aims and goals. This method of dotting the i can be found in the handwriting of an executive whose position calls for quick decisions.

Depression and feelings of pessimism can be attributed to a very heavy i dot. This handwriting trait reveals a writer who is feeling weighed down and projecting a heavy heart. An extremely light i dot signifies a lack of energy and a certain amount of apathy on the part of the writer. Sometimes the type of pen influences the type of i dot, so it has to be evaluated carefully.

i dot connected to the next letter

promised,

An i dot connected to the next letter in the word shows intelligence, quick thinking, adaptability, a positive outlook, and the ability to make long-term plans.

Letter i without the dot

details

An i with a dot that is omitted completely can indicate that the writer is a quick thinker whose thoughts flow faster than they can be written down on paper. Alternatively, it can suggest sloppiness in punctuation.

Pointed and sharp i dot

ring as it

Pointed and sharp i dots can indicate aggression and a sarcastic streak.

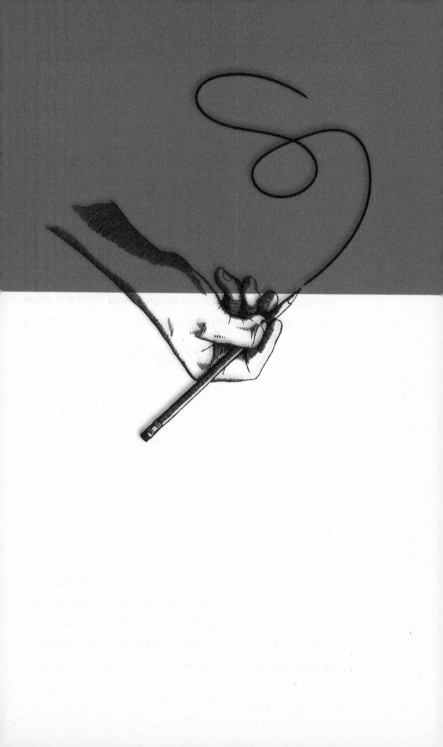

Signature: The Public Image

13

A signature is unique in the same way that a fingerprint is. It represents the image that the writer wishes to show the world at any specific time. A signature can change five or six times throughout one life span. Young people develop their own signatures around the age of fourteen, but an analysis of their handwriting should not be carried out until they reach maturity, and well after they have left school. By the time they are between the ages of twenty-one and twenty-seven, they will show signs of further changes to their handwriting, and a third period of change can be seen between twenty-seven and forty-two years. Further changes can occur in the fourth period, between forty-two and fifty-five years, and the fifth change happens from age fifty-five onward and will continue until an individual's faculties start to diminish and up until the time of death. In later life, the signature will remain the same but it may become shaky due to weakness in the arms, and it may start to slope downward due to illness or fatigue.

Many people use different signatures tor different purposes. For instance, a small signature may be used when important documents or checks are signed. Another type of signature may be used when a quick note is jotted down. A celebrity may use another type when signing autographs. A signature and the body of the letter being similar indicates that the person usually behaves the same way, whether in public or in private. A person with a legible signature is usually sincere and reliable, open and honest, and this writer has a good balance of expression in his or her personality. Illegible signatures can show an attempt to deceive others.

People whose signatures are illegible may be vain individuals who consider themselves superior, and they like to keep their thoughts to themselves.

Ascending signatures indicate optimism, while descending signatures can reveal pessimism, particularly if the pressure is heavy.

Individuals who end their signatures with a dot are displaying an obstinate and conventional attitude. They don't like explaining themselves to others, and they may avoid having to interact with others at times. The forename is associated with the writer's earlier life or experiences. If the first name is larger or smaller, weaker or stronger, than the second name, then there are unconscious memories, good or bad, affecting the writer emotionally, and these are reflected within the script. When a married woman makes her first name larger than the surname, this might show that she is in an unhappy marriage.

Types of Signatures

Embellished signature

A highly embellished signature with many whirls and loops shows a desire for attention. The writer is showing off, needs to be admired, and requires a lot of fussing in order to bolster a slight

inferiority complex. Individuals with this type of signature are usually loud and noisy and want to be noticed.

Small signature

m. Jane

A small signature displays inhibition, especially if the letters are squeezed and written tightly together. Such writers are withdrawn and show a need for protection, putting a distance between themselves and others for fear of getting hurt.

Encircled signature

L. Bloome

Signatures that are circled are indicative of writers who wish to withdraw. They are afraid of the world and other people, so they try to protect their ego by encircling their name in order to defend themselves and their loved ones. This handwriting feature can reveal depressive tendencies.

Rounded signature

A rounded and legible signature shows signs of honesty and reliability. This writer may have right-slanting writing, which displays an amiable and friendly nature and the ability to communicate and mix well with others.

Underlined Signatures

Many executive types will underline their signatures to add weight to their importance. Individuals who underline their signatures demonstrate a need to stamp their personality on the reader; this trait symbolizes a healthy ego and self esteem.

Many celebrities, show-business personalities, politicians, and others in the public eye tend to add a great deal of underlining flourish to their names in order to be noticed. Often the signature displayed is "over the top," which is a show of vanity; the result is rather vulgar.

Those who underline their signatures do so in many ways, varying in the length, firmness, and formation of the line. Underlining a signature is an indication of self-emphasis. A signature with no underline portrays an attitude that is not demanding or showing a need to be recognized. In some cases the person's signature has no lower loops, so the addition of an underline is a way of drawing this lower area into the person's signature. Here are a few examples to illustrate this trait.

Long, thick underline

A long, thick underline can be an indication of aggression, with drive and energy toward progress.

Normal-pressure underline

An underline written with normal pressure demonstrates self-confidence and self-constraint.

Strong, rising underline

A signature with a strong, rising underline to the right is an indication of a forward-thinking and ambitious individual.

Underline hooked on both ends

An underline that is hooked at each end indicates that this individual is crying out for recognition. A hook on the left of the underline indicates a need for recognition of past achievements, and a hook on the right of the underline shows that the person is striving to achieve.

Crossed underline

A crossed underline is indicative of a money-conscious person.

Ornately decorated underline

People who decorate the underline under their signatures find themselves fascinating and they are particularly concerned with their appearance. They may act or speak in an artificial manner to impress others.

Short and light underline

A short underline created with light pressure is showing a lack of drive and energy.

Several Underlines

A signature with several strokes to the underline can denote a self-assertive, overbearing, uncompromising individual.

Two Different Underlines

The writer who has two different types of strokes underlining his or her signature is displaying a great need for attention. This individual may use an assumed manner of speech, dress, or behavior to impress others.

Crossed strokes underlining a name can indicate a sign of anger or a sarcastic streak. This writer does not suffer fools gladly and likes to be seen as a dominant individual.

Mixed Writing

Small writing and large signature

I hope you all have a marvellous time in Fuerteventura.

E. Spackell

People with small writing and a large signature are expending significant energy on overcoming the conflict between their private, quiet nature and a need to be noticed. The gap in the size, from small writing to a large signature, indicates a big difference between the way such people feel inside as private individuals—and how they present themselves as people who get attention.

Small writing and small signature

draw to a close here and brings a full recovery

M. Fare

Small writing accompanied by a small signature is often characteristic of a person who has good concentration skills but who also can be introverted. People whose handwriting is small and who have a small signature pay particular attention to minute details, so care should be taken to ensure that all the facts are at hand when working with them.

Medium-size writing with a large signature

Hello,
Please send me information
about correspondence courses.

Thanks

(R.J. Sprocckett)

It is not unusual for people to sign their name a little larger than they normally write. This characteristic is a very common writing trait, and it is an indication that they are making an effort to be noticed.

Medium-size writing with a small signature

Happy New Year.

Fred etc.

A person whose signature is smaller than the accompanying text can be displaying inhibition, timidity, meanness, or unsatisfactory attitudes at home.

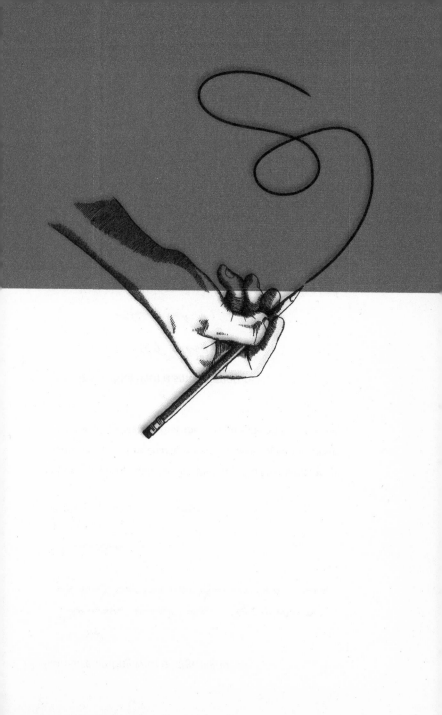

Practical Applications 14

Graphology is much like palm reading and astrology when it comes to its practical applications: the lines of the hand, a birth chart, and an individual's handwriting can all provide empirical insights into oneself and others; it can reveal personality characteristics that may otherwise go unspoken. Whether consciously or unconsciously, we are all reacting to and making assumptions about others based on their handwriting. That includes employers, dates, and teachers—anyone in a position to judge others will invariably take handwriting into account.

Now that we have covered the basics of handwriting analysis, let us see how a professional might use the system. Here is the story of two women who answered an advertisement for a job.

Candidate A and Candidate B are waiting to be interviewed by a specialist at their local hospital. They have been short-listed to attend an interview for the post of personal assistant. Part of the job description is to communicate with patients in person, by letter, and on the telephone, regarding appointments and general inquiries.

In terms of qualifications and experience, there is little difference between the two applicants, as they have both worked in busy medical practices for a number of years. Faced with the challenge of choosing between the two candidates, the specialist gives a sample of each woman's handwriting to a graphologist for analysis. Both candidates are married, and they are both in their forties. To distinguish between them, we will call Candidate A Beryl and Candidate B Joan. By reading through the analyses of the two handwriting samples, it should be possible to ascertain which candidate was selected for the position.

Beryl's handwriting

Please forward the relevant literature for the courses.

Beryl's sample reveals evenly spaced margins with a slight right-handed slant, and her script is of medium size, with her small letters predominantly in the middle zone. Her baseline is relatively straight, and the spacing between her words is neat and even. Also, the distance between the lines is basically normal. Her letters are mostly connected and her style of writing is garland.

This sample shows a woman who has good planning skills. She is friendly and has an outgoing disposition, and she enjoys human contact. Her social instincts are well developed, and she can leave her ego aside and focus on others when she interacts with them.

Beryl's handwriting indicates a person who is practical, flexible, and adaptable and has good organizational abilities. She is a thinking person who keeps her own emotions in check. She is orderly, methodical, and responsible and feels genuine concern for her fellow human beings. She is a clear thinker with inner balance and harmony, and she has a logical approach to solving problems as they arise.

This woman's writing reveals that she is expressive, cooperative, and usually at ease with most people and with the environment, and she normally avoids conflict.

Joan's Handwriting

*I have been too snowed-under to study but
I really do want to start at some point!*

Joan's handwriting sample shows a wide upper margin with a more pronounced right-handed slant. Her script is small and most of the letters are within the middle zone. The baseline is descending, and her words are widely spaced. Also, her letters are narrowly divided within the words, and her style of writing is arcade.

Joan's writing shows that she is respectful of her employer and elders and tends to live in the present with little thought for the future. She can be irresponsible and overly sentimental. Although she is sympathetic, she can be embarrassingly demonstrative. She has a tendency to analyze everything, including her thoughts and feelings. She is a thinking person, and she uses an analytical approach to the problems of life. Her writing indicates that she can be prone to fatigue if she is overworked and that she is unable to labor under pressure. This tendency can lead to a pessimistic attitude, and she can become depressive.

Although her writing shows intelligence and independence, she may take time and effort to think through her problems carefully before making a decision. She has a tendency to be introverted and overly cautious, and she lacks faith in her own abilities. Joan prefers to keep her own counsel, and she rarely lets others know her true thoughts and feelings, at least until she has worked them out for herself.

She can mix and communicate well with others when necessary, although she likes to keep her personal life private.

Which candidate do you think was offered the position? In this particular situation, given the requirements of the job, the successful applicant was Beryl. Joan went on to pursue another successful career that was in perfect harmony with her personality.

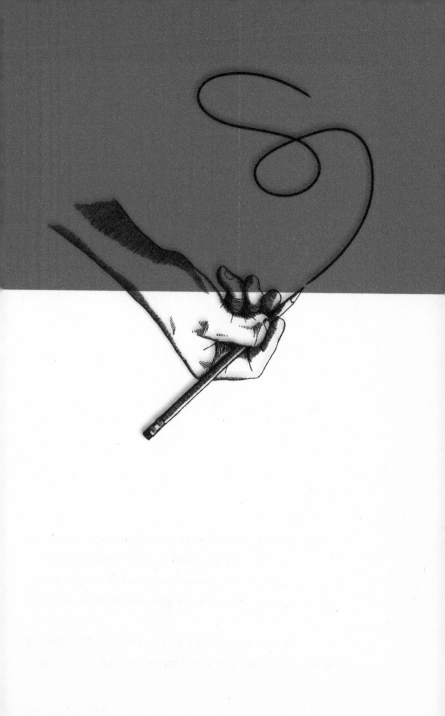

Keywords
and Traits

15

Keyword	Indicators or traits
Adventurous	Right-slanted handwriting; broad, large upper and lower zones; firm pressure on page and narrow right-hand margin
Ambitious	Large writing with rising lines and firm pressure; large middle and upper zones; large signature with a strong rising t bar placed high on the stem
Amiable and adaptable	Medium-sized writing of average width with flowing, harmonious rhythm; rounded letters and garlands
Business acumen	Large lower zone; letters mainly connected but some disconnected; right forward slant; threadlike writing with mixed connections or angles; broad, medium, or large size; no right margin
Calm and poised	Upright or slightly left-handed slant to regular writing; rounded letter forms with straight lines and regular spacing

Careless	Irregular threadlike handwriting; letters broken with bodies incomplete
Cold natured	Left-handed slant to script with narrow and sharp strokes; angular letter connections and words widely spaced
Conventional	Copybook connections; writing medium-size to small; straight lines; upright or slight right-handed slant with balanced zones and regular spacing; letters connected
Decisive	Angular connections; regular writing; careful letter-forms
Economical	Narrow, small writing without any end strokes to letters; no margins whatsoever
Efficient	Regular handwriting with angular or copybook connections; carefully formed letters with i dots and t bars accurately placed
Extravagant	Large, broad writing with wide left margin; large spaces between words and lines

Extrovert personality	Large, broad writing with a right-handed slant; large middle-zone words close together, with all spaces filled
Fiery tempered	Forward right-slant with heavy pressure and angular connections; fierce, pointed, or thickened t bars and hooked starting strokes, or script starting from well below the baseline
Generous	Broad handwriting and large garland end-stroke letters
Good judgment	Clear, regular, legible, medium-size handwriting with upright or slight forward-slant connected letters; straight lines and margins
Imaginative	Large, broad handwriting; letters disconnected; large upper and lower zones with full loops to script and irregular writing
Indecisive	Threadlike connections; broad, irregular handwriting with lack of definition to letter forms

Inferiority complex	Small, narrow handwriting with light pressure and left-handed slant; descending lines, small signature, and small personal pronoun I
Introvert personality	Small, narrow handwriting with light pressure and left-handed slant; small middle zone and words wide apart with spaces left vacant
Modest	Small handwriting, small signature, small personal pronoun I, and small upper and middle zones to letters
Obtrusive	Very broad writing with firm pressure and angular connections
Optimistic	Rising lines with a dynamic, lively stroke and rounded letter forms; signature clear and rising, placed to center or right-hand side
Pessimistic	Falling lines and falling words with angular connections and broken letter-forms; signature crossed through or placed to the left

Precise	Regular handwriting with straight lines and margins; letters clearly and meticulously formed with angular connections; accurate placing of i dots and t bars
Secretive	Handwriting completely connected, with arcades or copybook vowels such as o tightly looped and sealed; cover strokes retracing letters
Self-confident	Large, regular handwriting with large middle zone; upright or slight forward slant; large signature and large pronoun I
Self-disciplined	Regular handwriting; straight lines and margins with even word spacing; balanced zones with upright or slight slant
Sensual	Thick, indistinct stroke; broad handwriting but narrow word spacing; large letters in lower zone

Sociable	Broad, legible handwriting with harmonious rhythm; forward right-slant and words close together; large middle zone; letters connected with garlands; rounded letter forms
Tactful and diplomatic	Medium-size or small handwriting of average width with rounded letter forms and even pressure; garlands, arcades, or mixed connections; upright or slight forward-slant; words decreasing in size with wide spaces between them
Talkative	Large, broad handwriting connected with garlands; words and lines close together
Timid	Upright or left-handed slant; narrow, cramped letter forms, light pressure, and wide right margin
Unpredictable	Changing slant, irregular handwriting, and varying connections

Versatile	Irregular handwriting with some letters connected and others disconnected; rhythmic, flowing, and varying letter forms with threads, garlands, or arcades
Warm natured	Broad handwriting with a pasty, thick stroke, rounded letter forms, and words close together; right-handed slant

ABOUT THE AUTHOR

Eve Bingham was born Evelyn Rose Curtis in the east end of London, the fifth of six children. Eve has always had an interest in what is now termed the esoteric arts, and in the early 1970s she became active in her specialized subjects: tarot, numerology, graphology, spiritual development, relaxation, and meditation. She joined the British Astrological and Psychic Society (BAPS) in early 1978, and she also served many of the spiritualist churches in Britain.

Try another practical guide in the
ORION PLAIN AND SIMPLE series

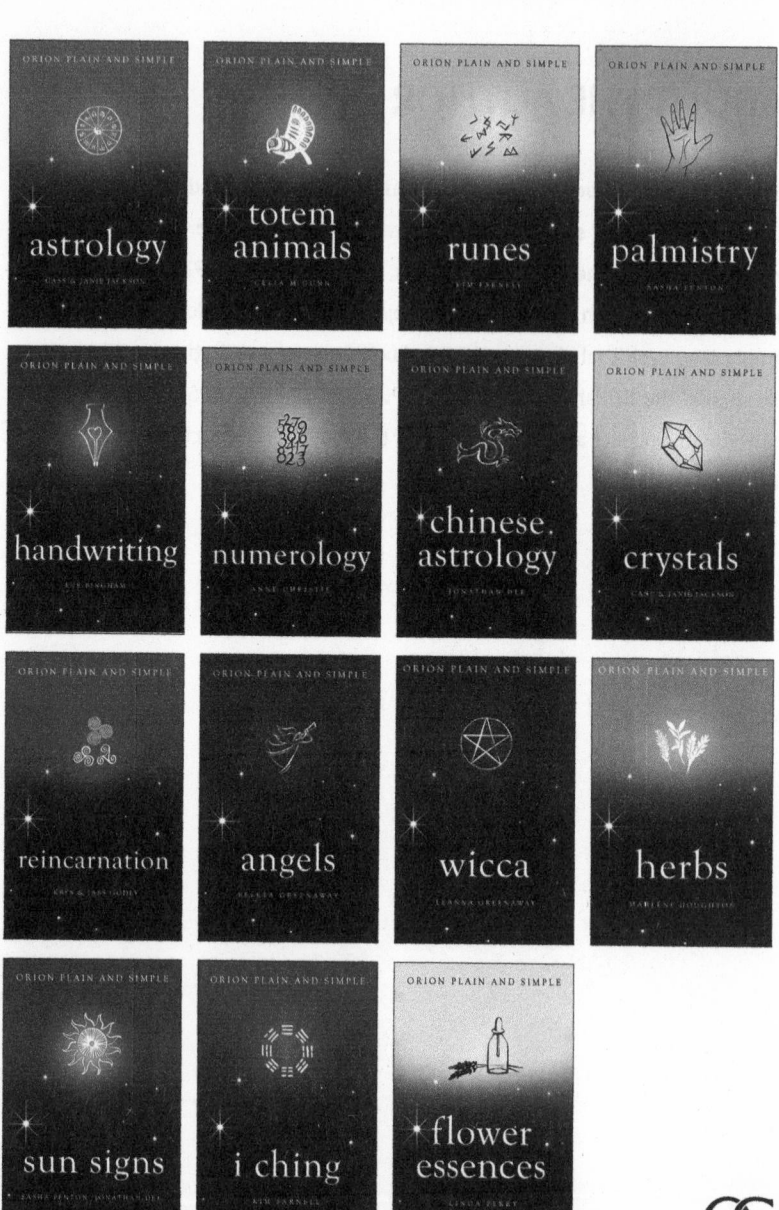